SOME TWENTY ODD VISIONS

Blue Sky would like to thank our many friends, and especially the National Endowment for the Arts, a Federal agency, the Oregon Arts Commission, the Rose E. Tucker Charitable Trust, and H. L. P. Leadbetter Trust for their contributions to this book and the exhibition which it accompanies.

Nancy Rexroth's photographs are courtesy of Light Gallery.

John Levins took his photographs between the ages of two and a half and four years.

Distributed by University of Washington Press
Seattle London

Library of Congress 77-87215
ISBN 0-931194-01-6
Copyright©1978 Oregon Center for the Photographic Arts, Inc.
All Rights Reserved

Design by Ann Hughes
Cover photograph by Craig Hickman
Back cover photograph by Christopher Rauschenberg
Printed by Rapoport Printing Corporation, New York, N.Y.

Any inquiries regarding this book or exhibition should be made to Blue Sky/Oregon Center for the Photographic Arts, Inc., 117 N.W. Fifth Avenue, Portland, Oregon 97209

SOME TWENTY ODD VISIONS

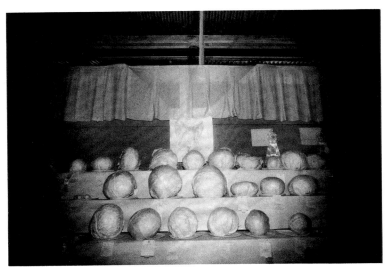

Ford Gilbreath

Assembled and edited by Blue Sky Gallery

Robert Di Franco
Craig Hickman
Ann Hughes
Christopher Rauschenberg
Terry Toedtemeier

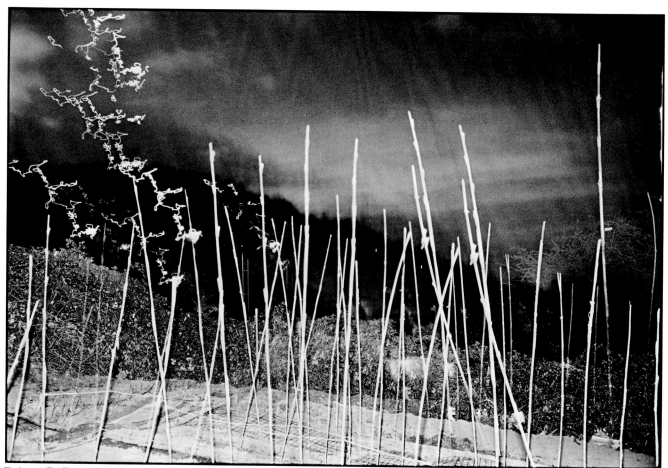

Robert Di Franco

These photographs are maps to get lost by. They are not instruments to guide our travels through the unknown. Rather than making new territory familiar, they make familiar territory new. As children, we never quite knew what was going on, and the world was filled with mystery. Now that we have grown up and found out what things are, we have forgotten how to imagine what else they might be. We are creatures of habit, and have come to an agreement about how the world looks. However, in these photographs the normal everyday objects and spaces that we take for granted lose their familiarity, and the world regains the richness and mystery that we once saw.

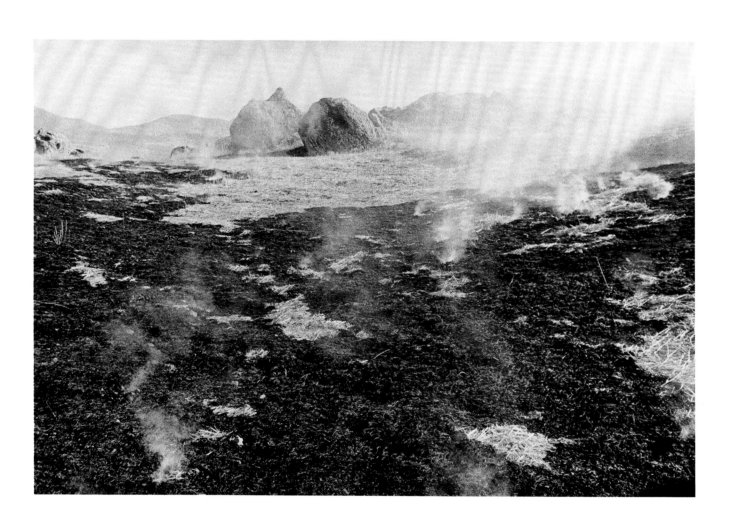

Ingeborg Gerdes

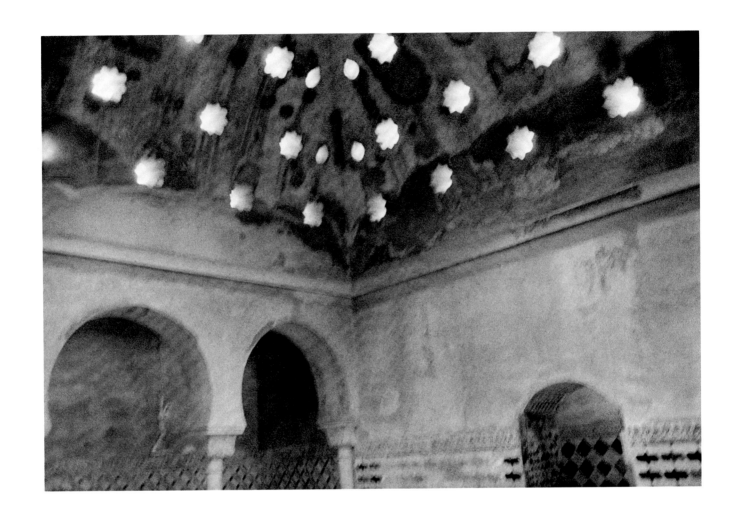

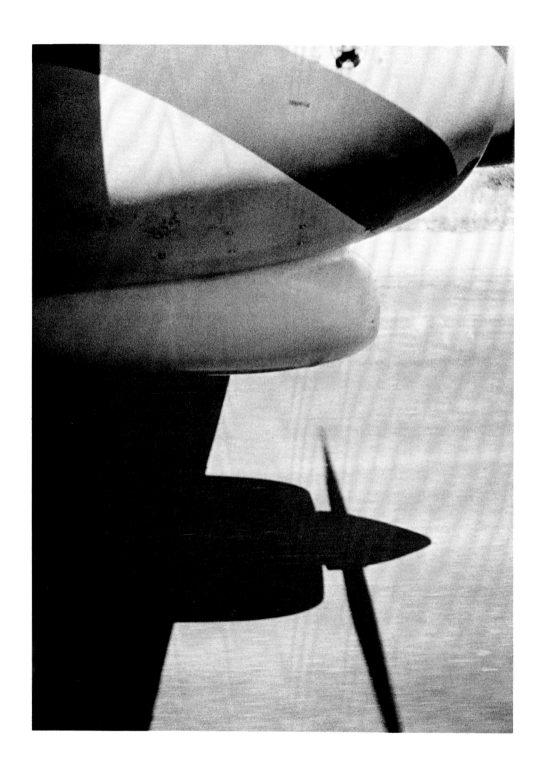

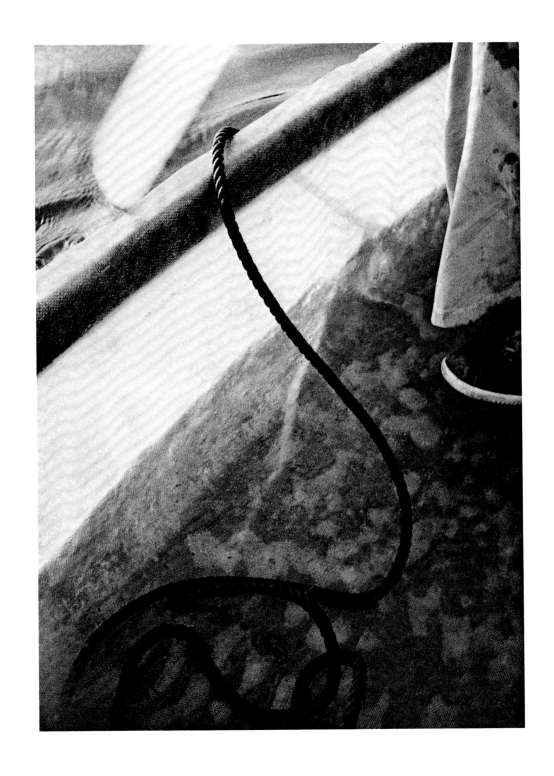

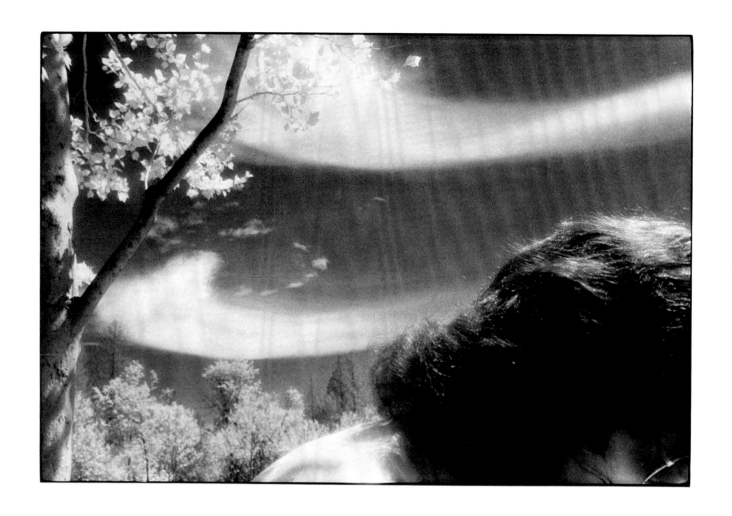

Bob Iyall

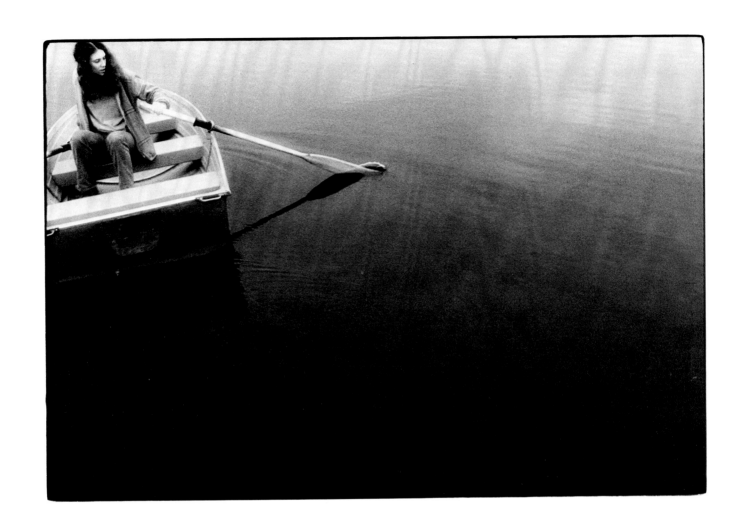

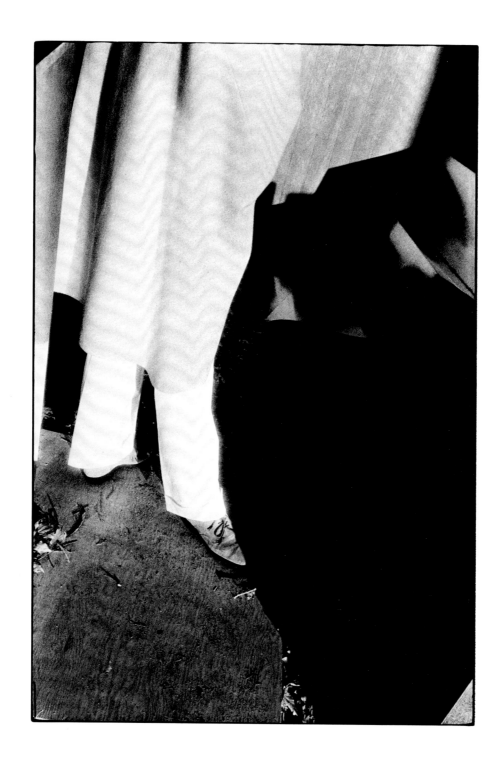

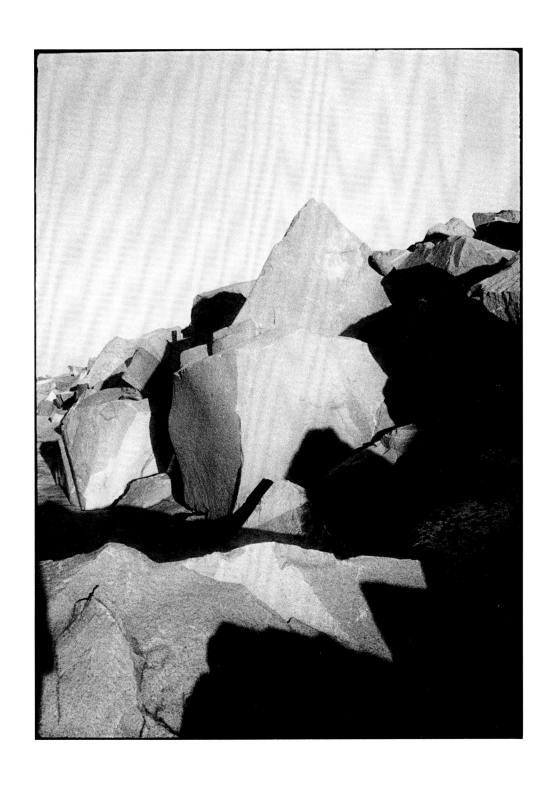

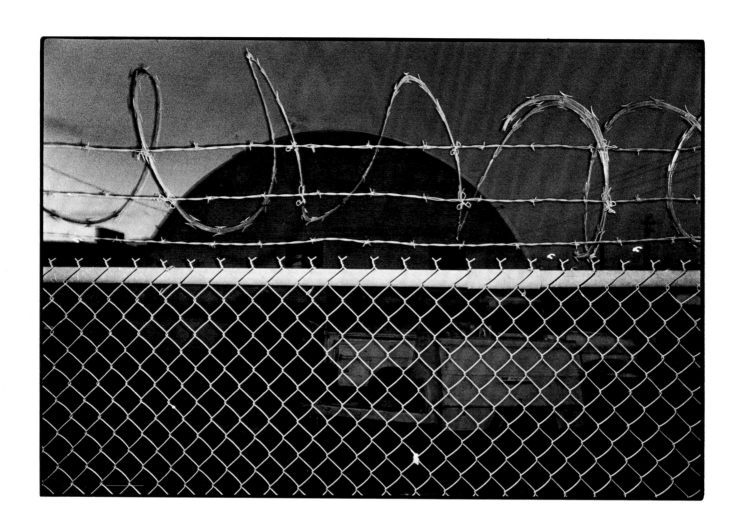

Jim Dobbins

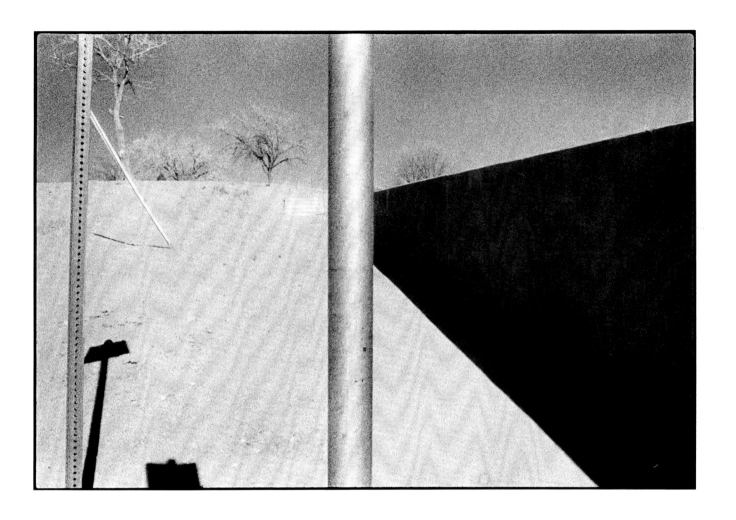

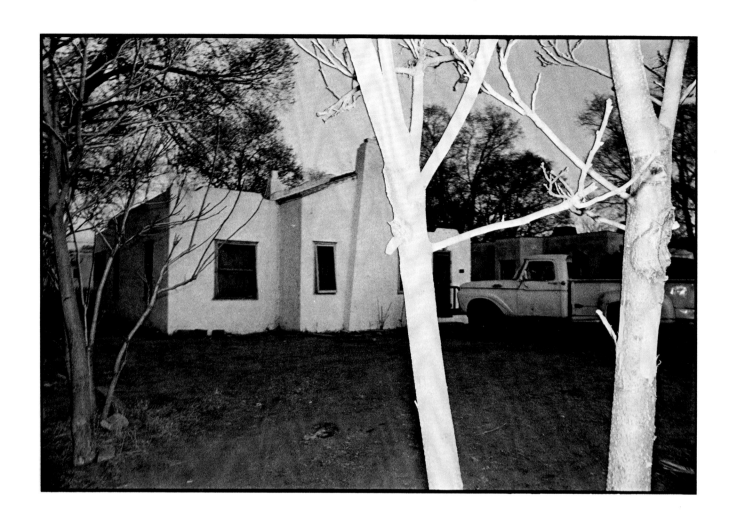

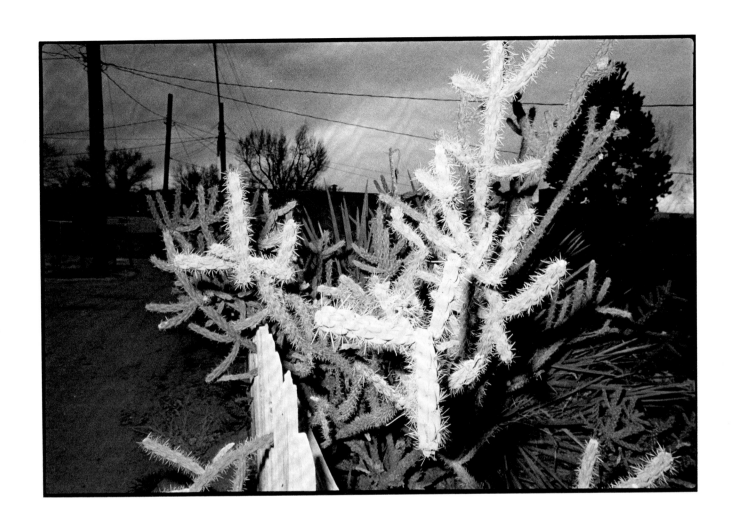

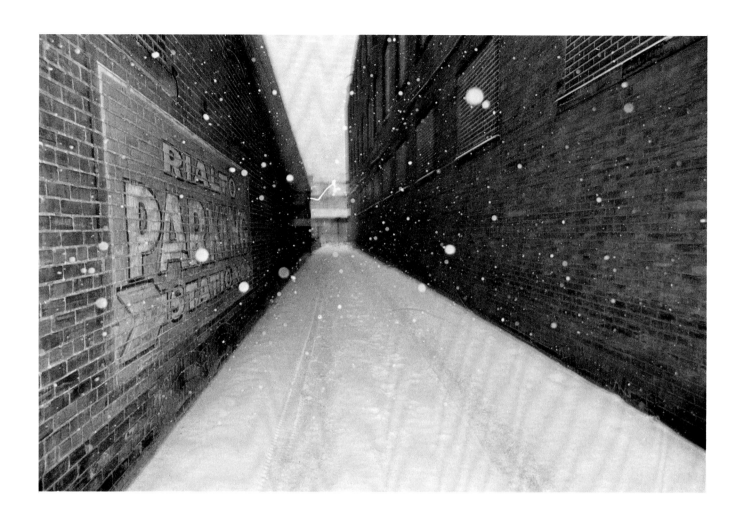

Mark Cohen

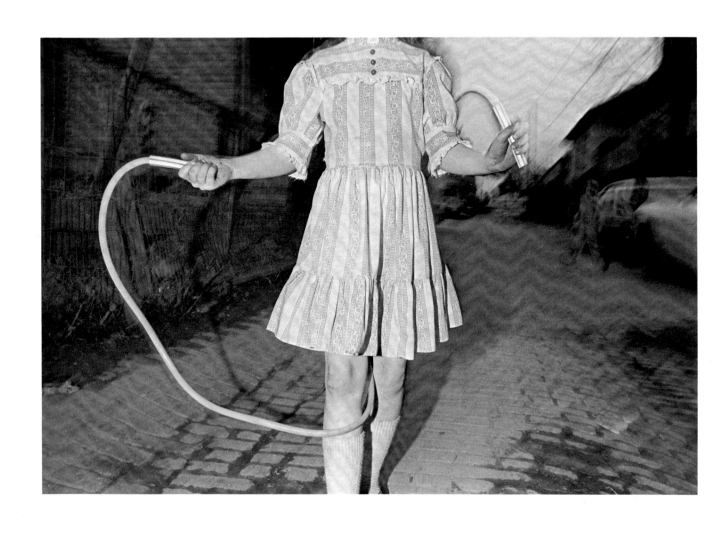

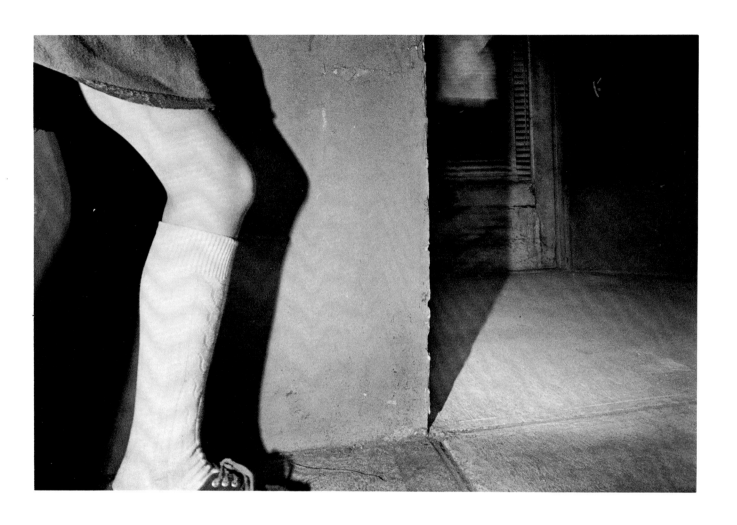

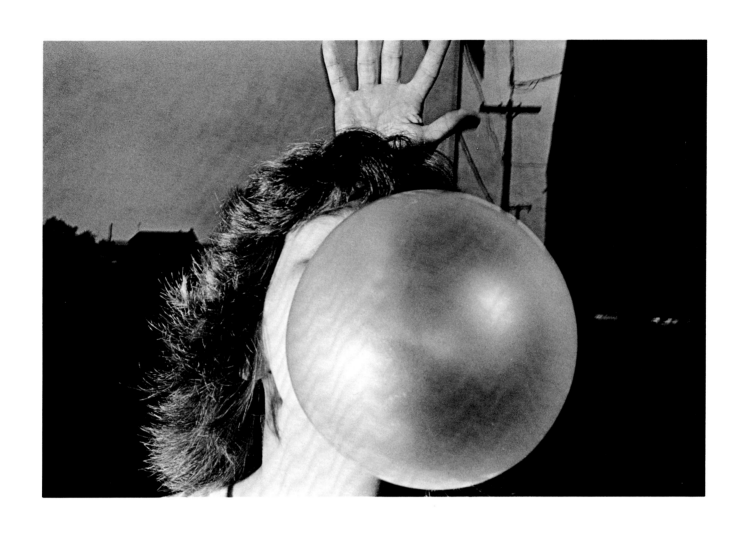

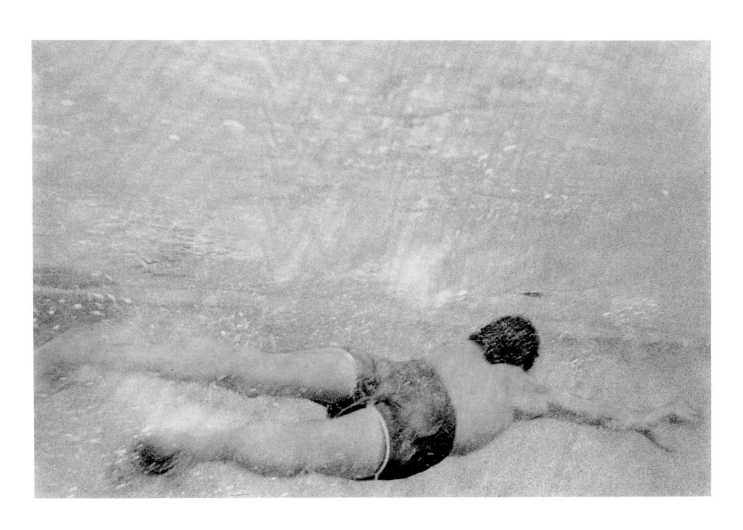

Julie Mihaly (Originals blue toned and hand colored) 22

Terry Toedtemeier

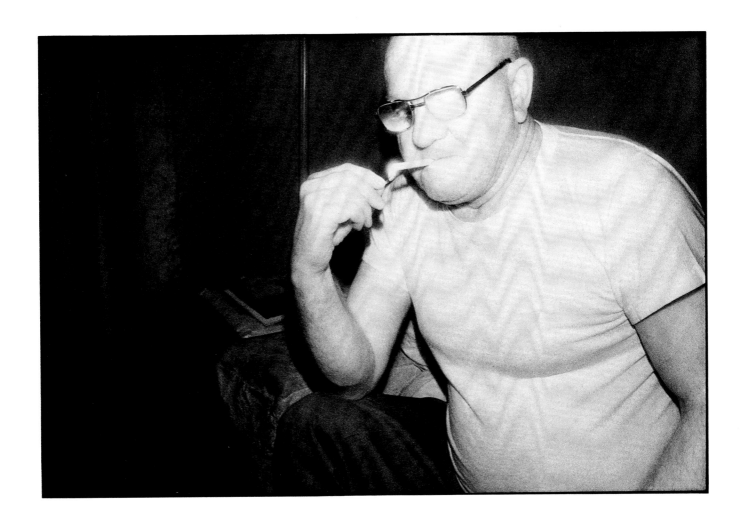

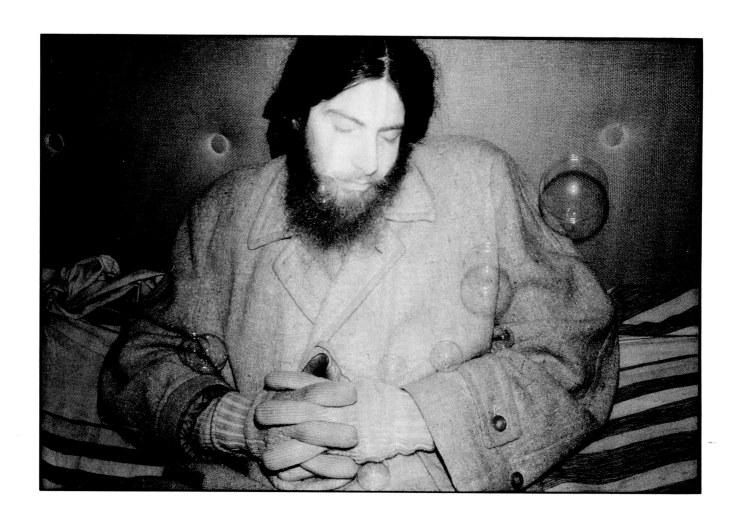

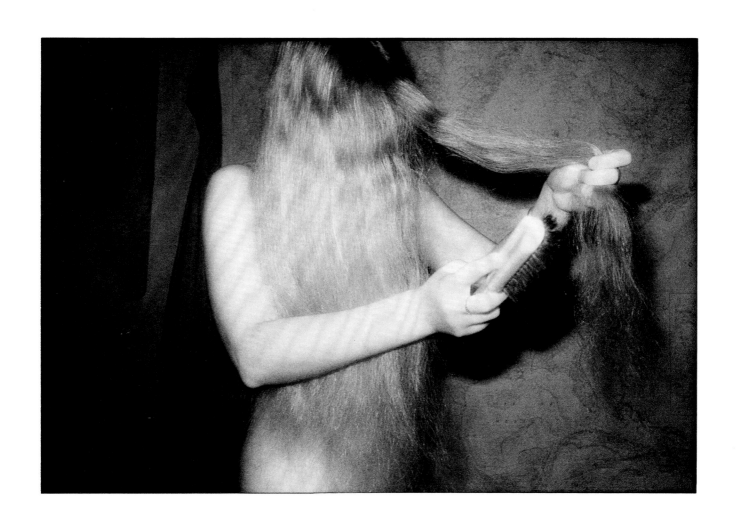

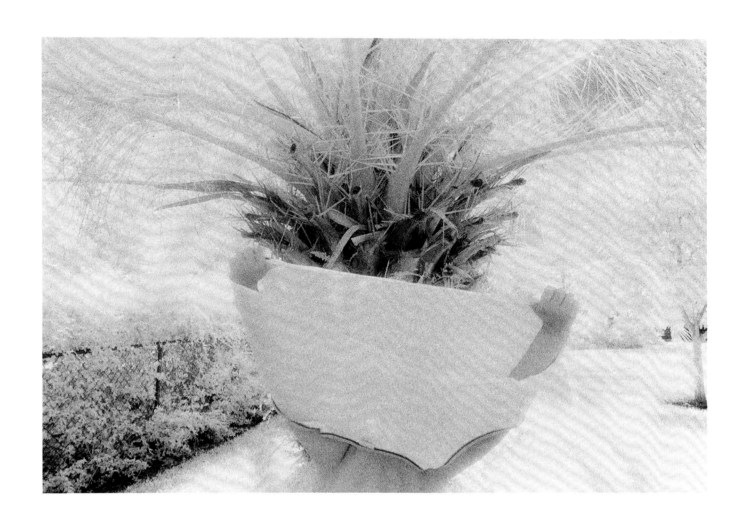

Abigail Perlmutter

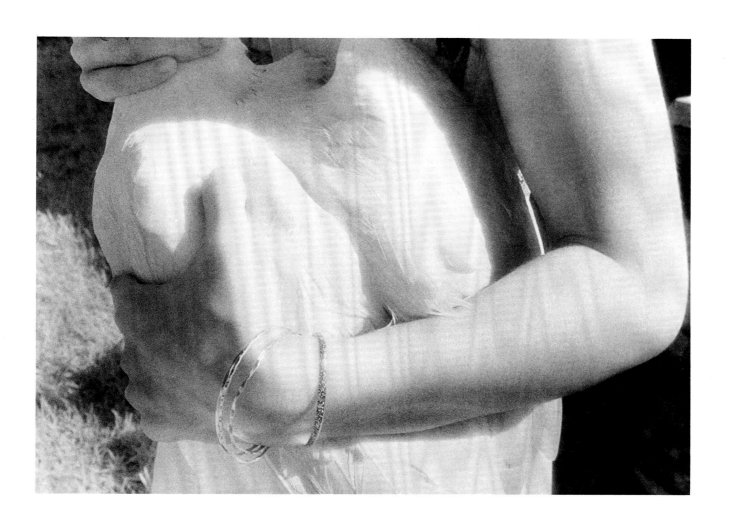

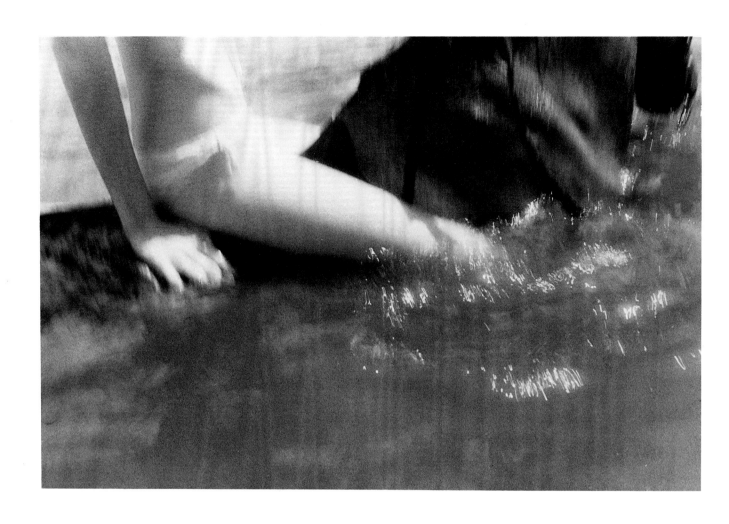

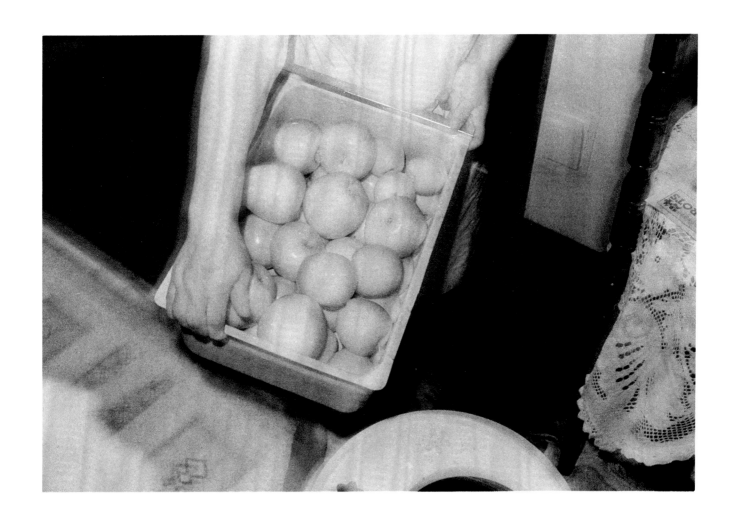

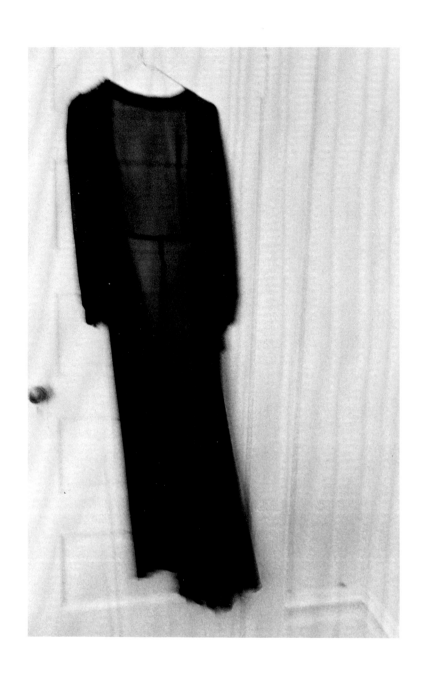

Donna-Lee Phillips

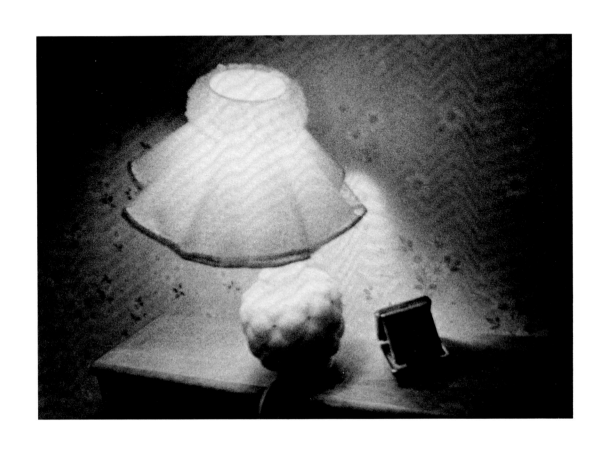

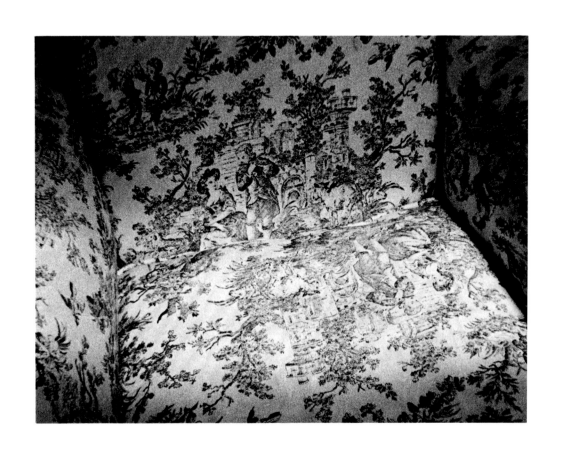

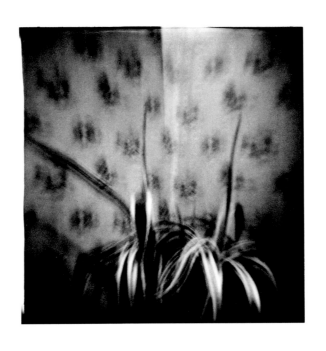

Nancy Rexroth

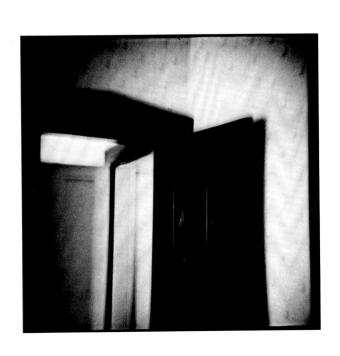

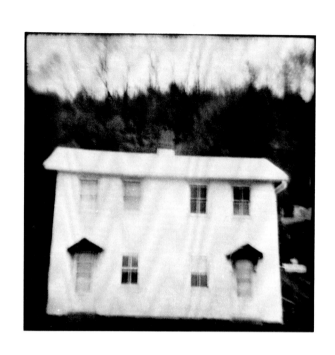

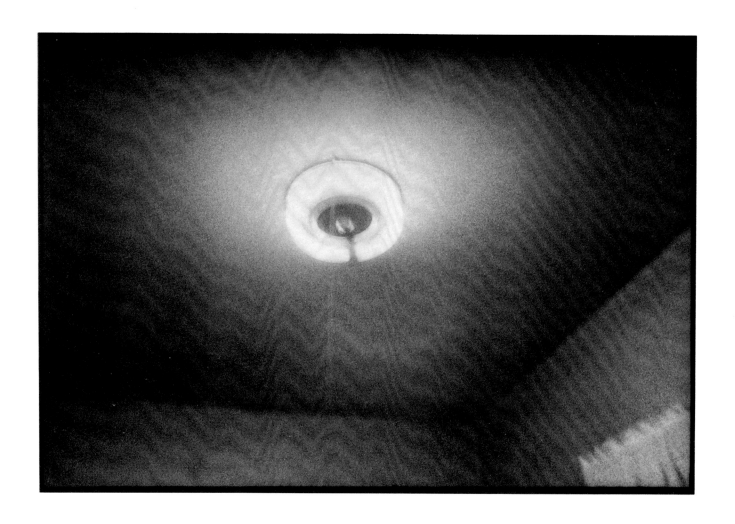

Richard Hobbs

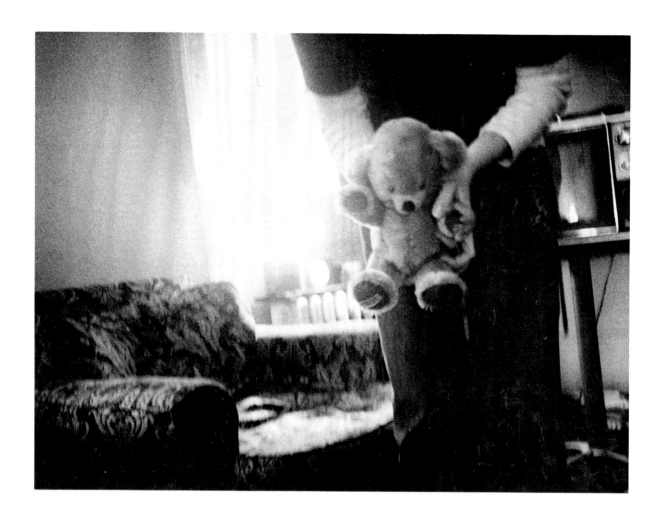

John Levins 44

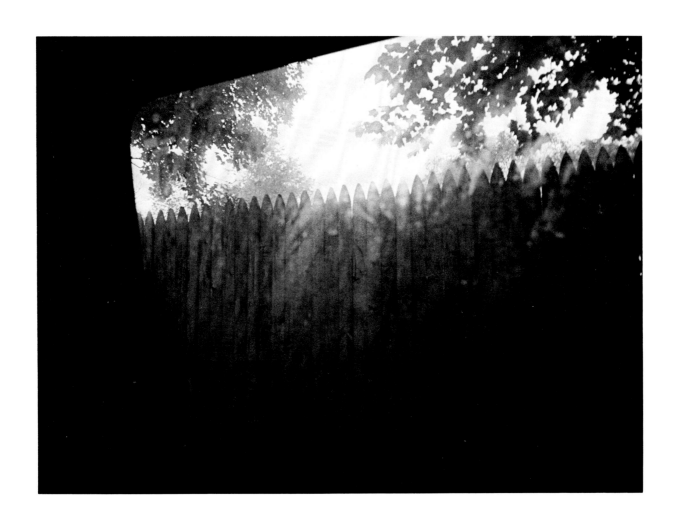

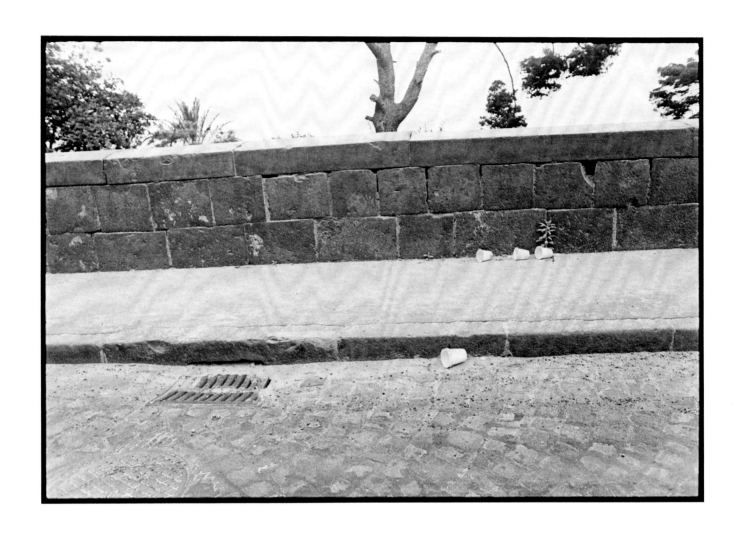

Christopher Rauschenberg

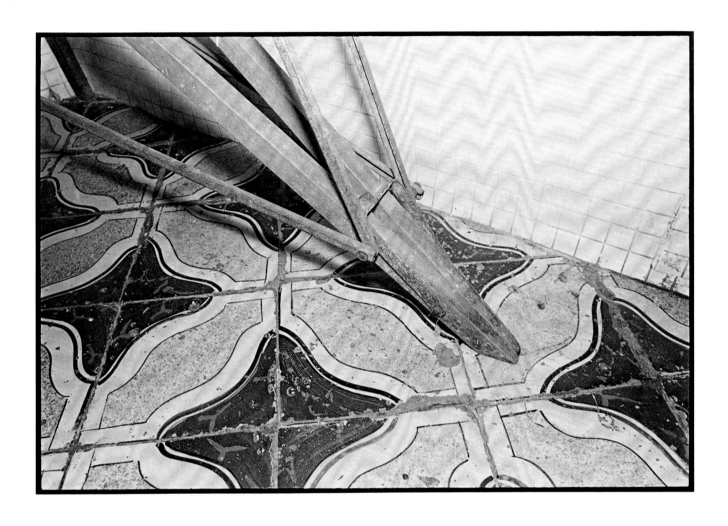

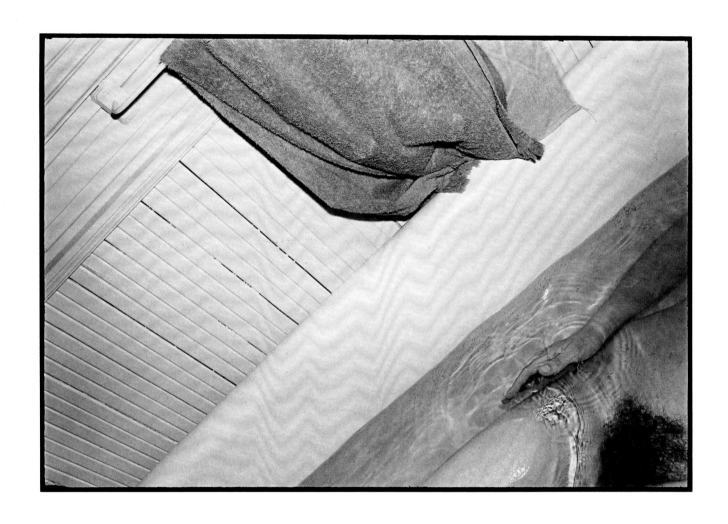

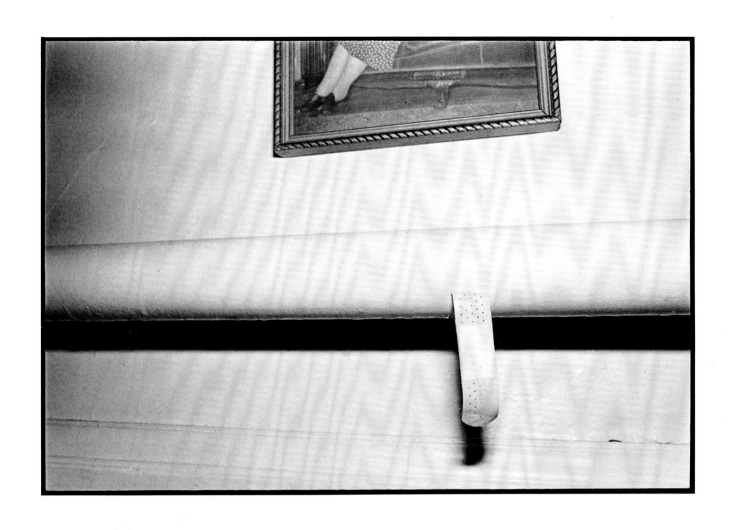

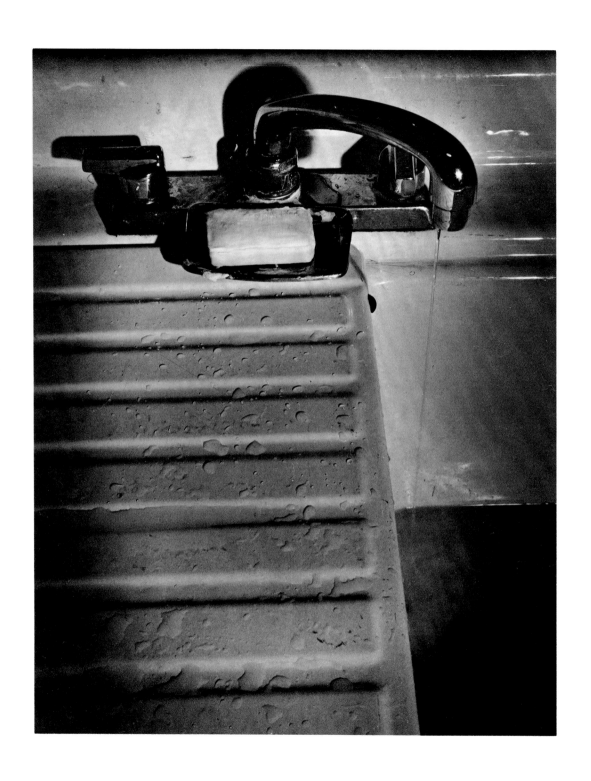

Curtis Bunyan

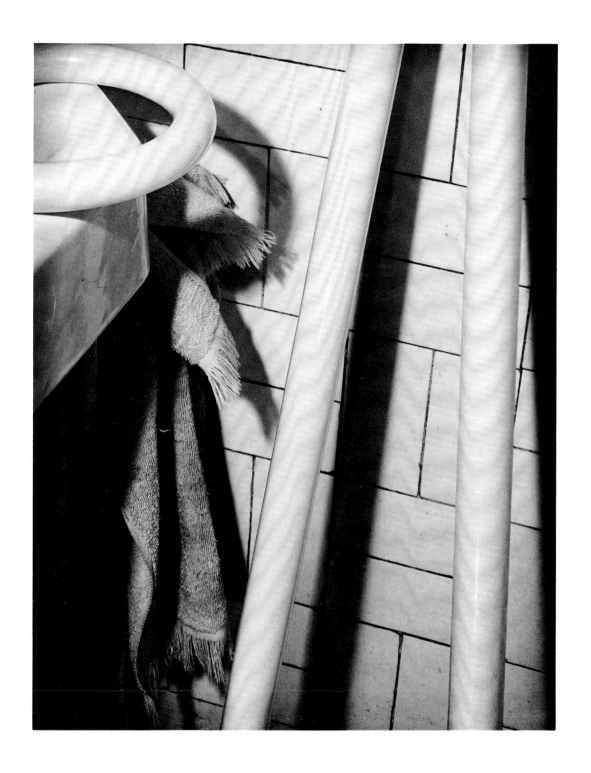

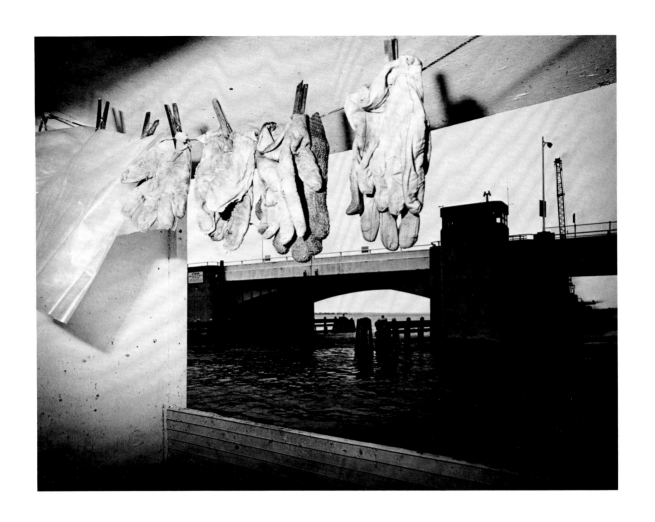

Ken White

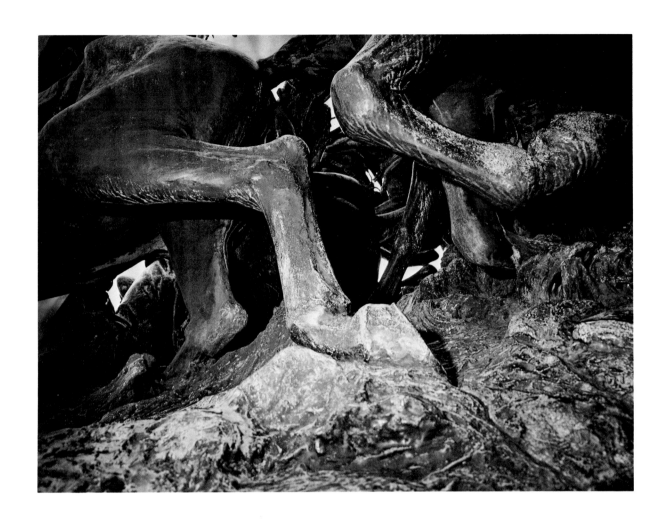

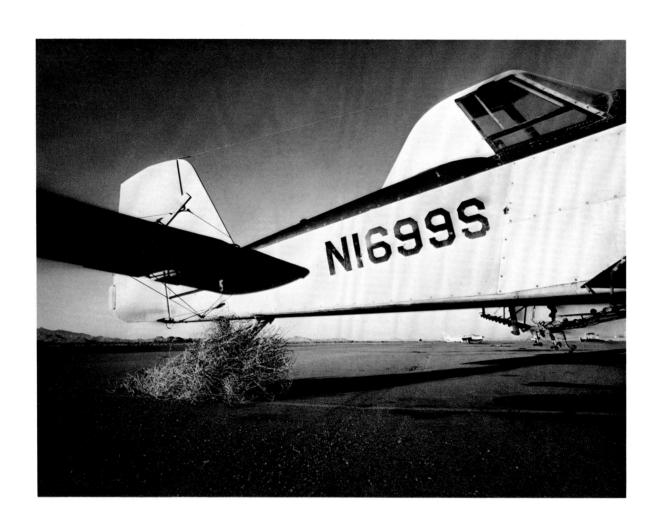

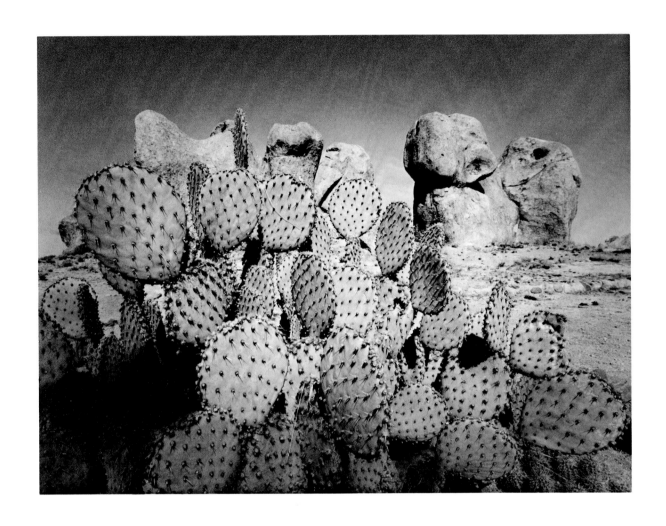

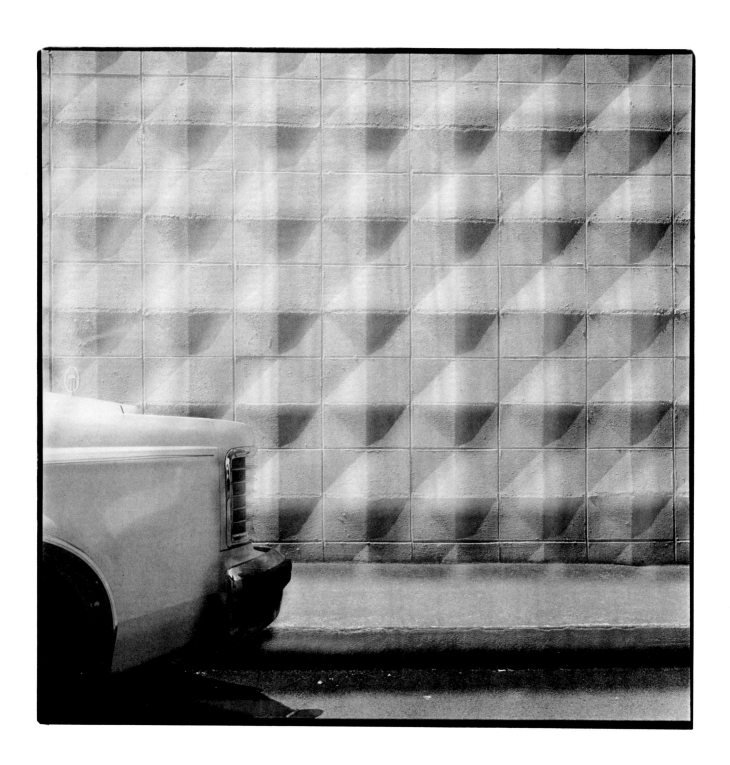

David Pearson

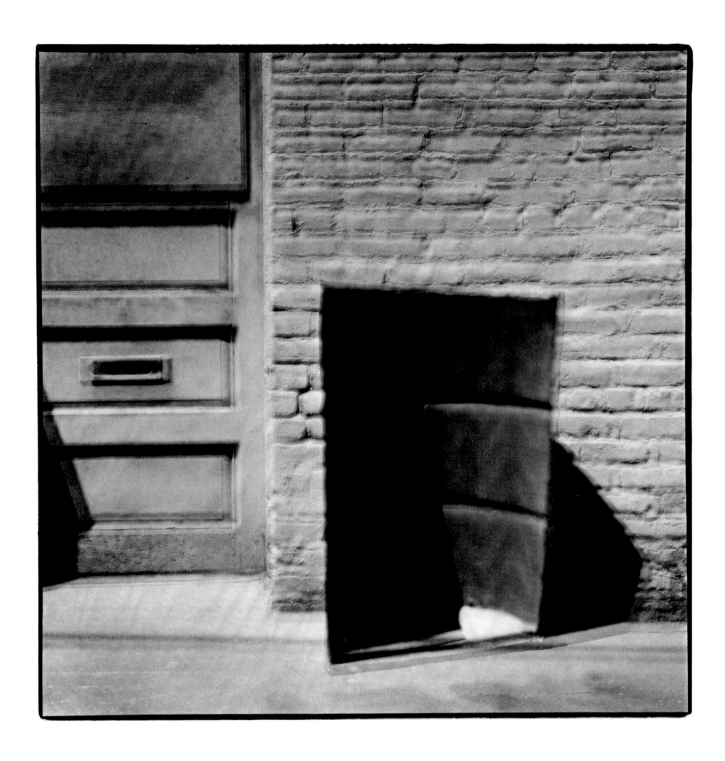

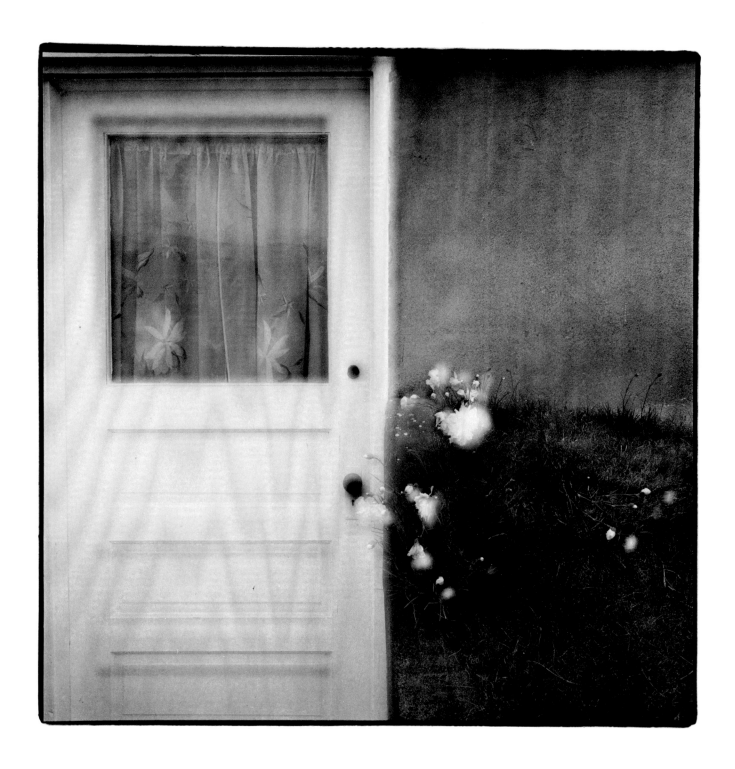

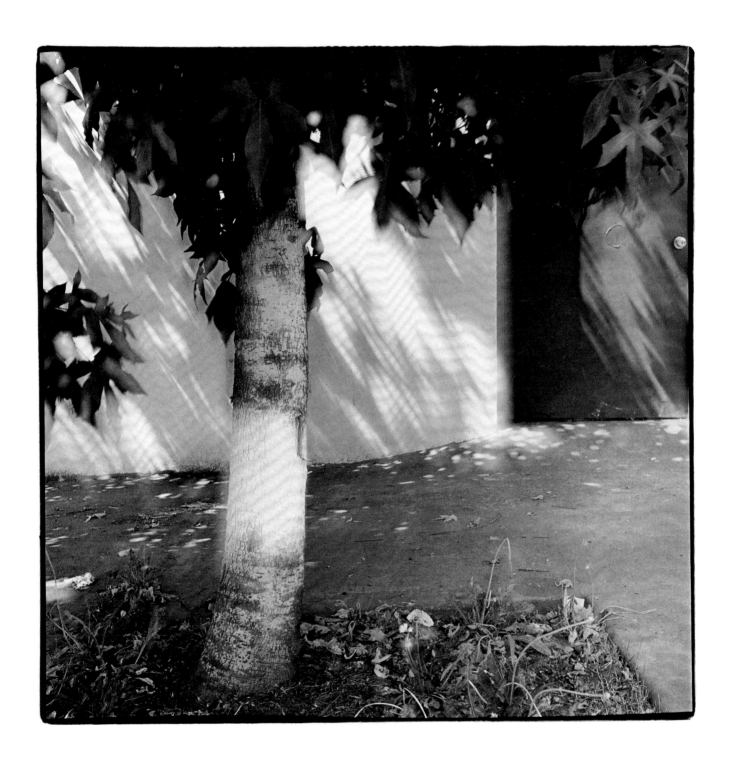

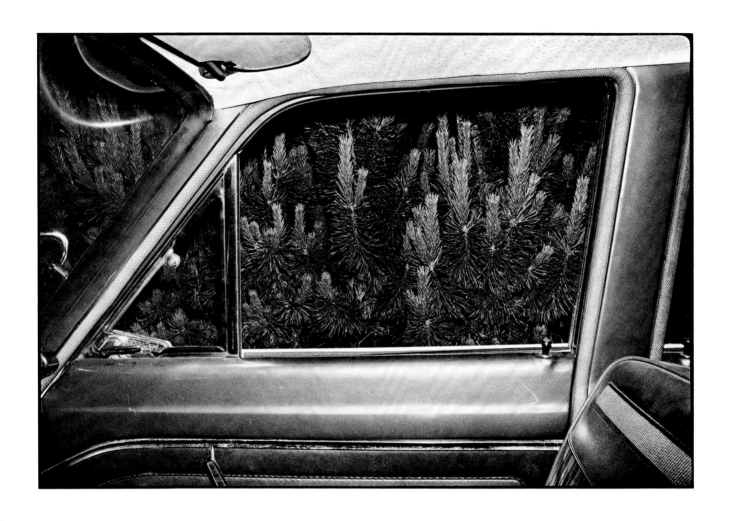

Robert Di Franco

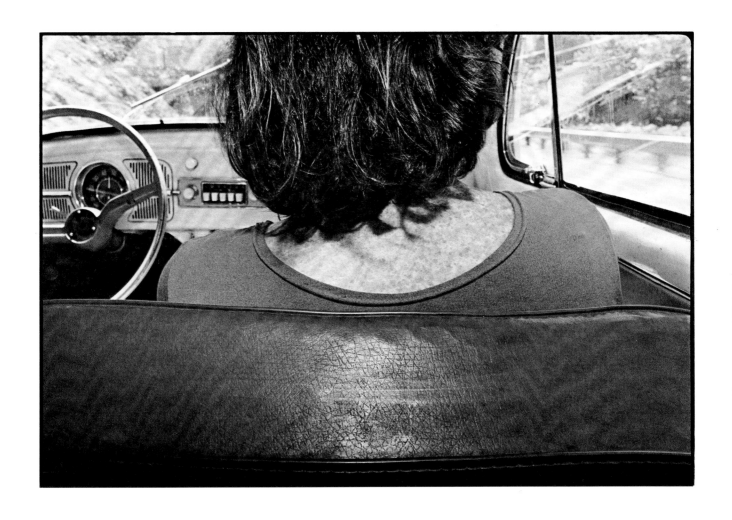

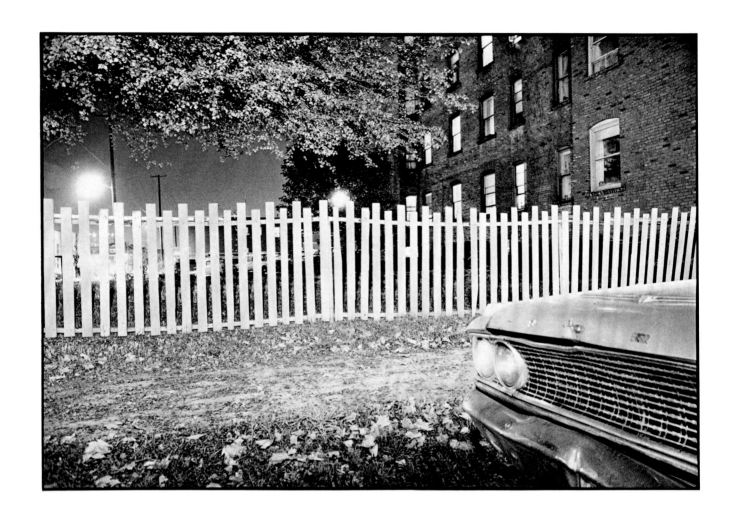

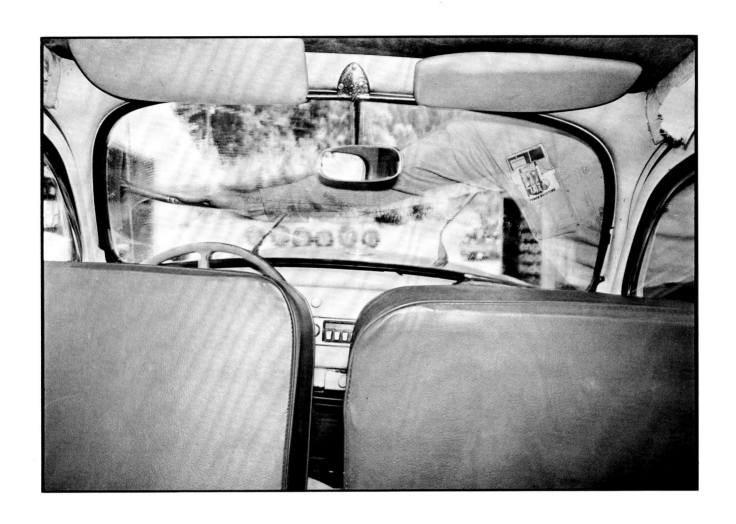

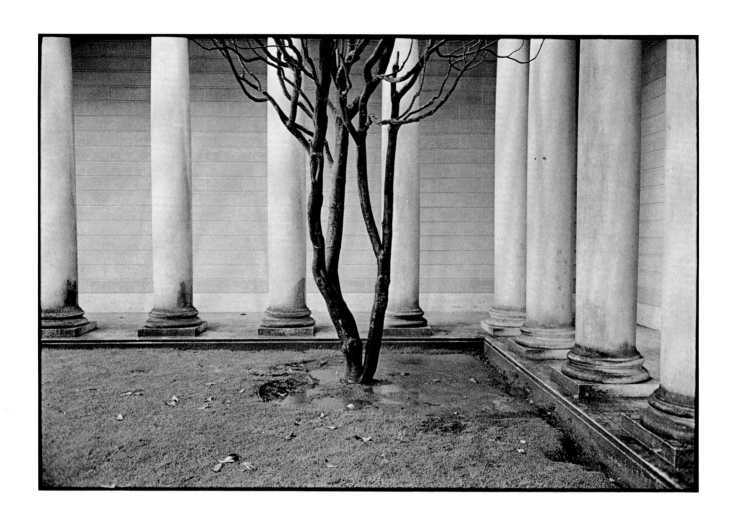

Kirk Thompson 66

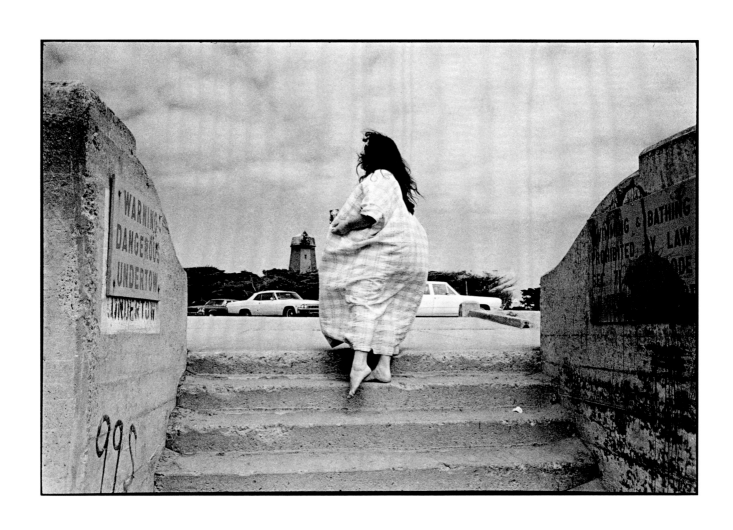

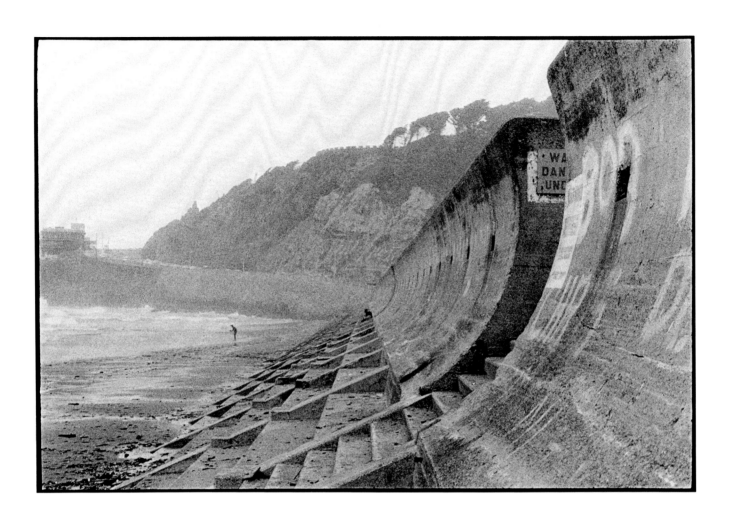

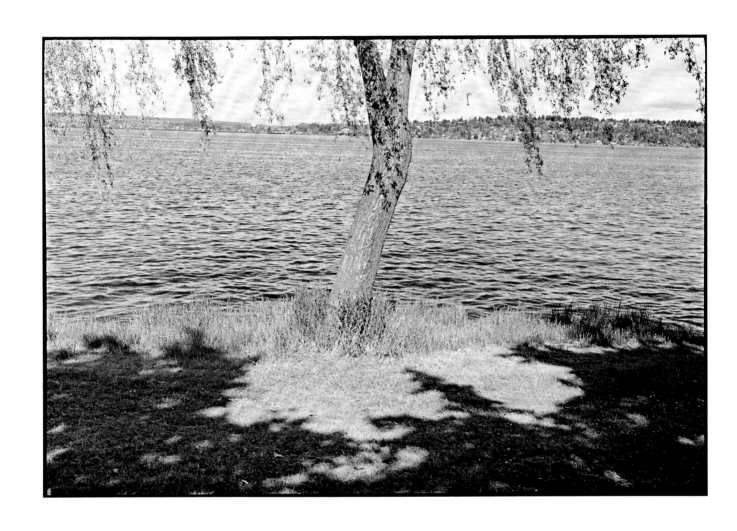

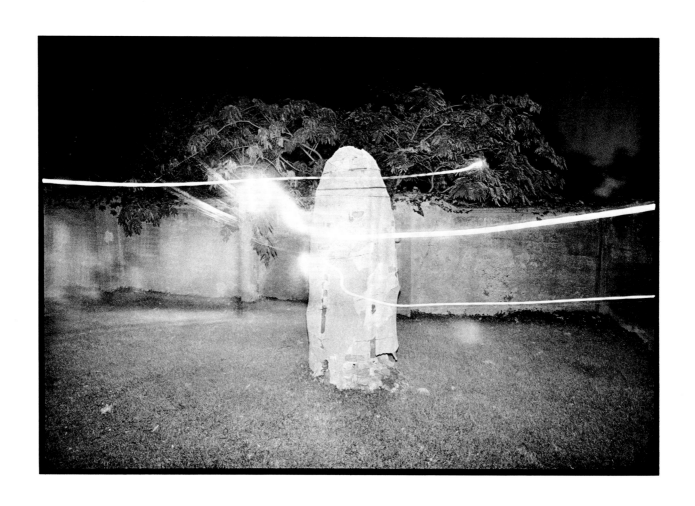

Michael Becotte

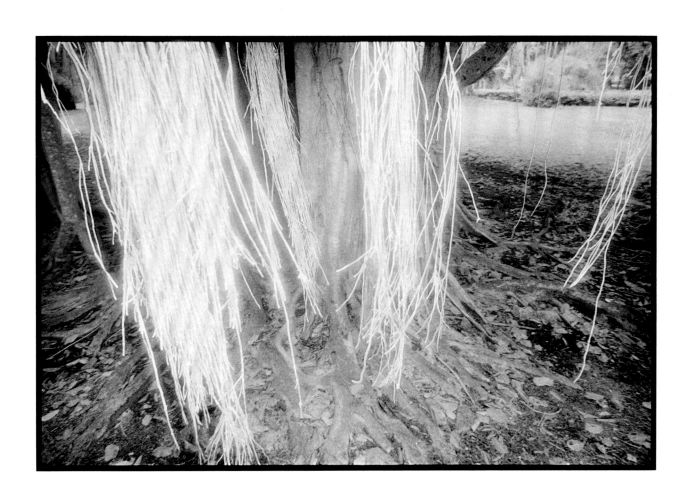

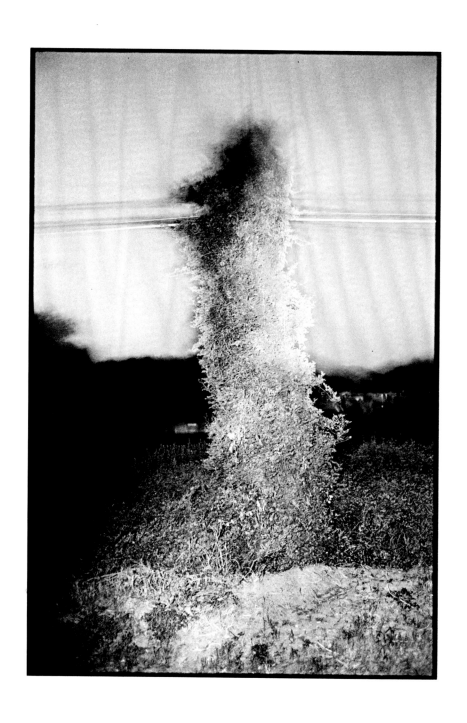

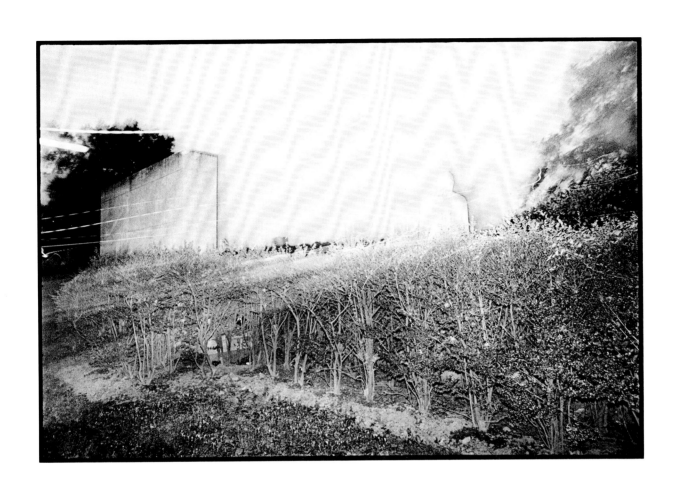

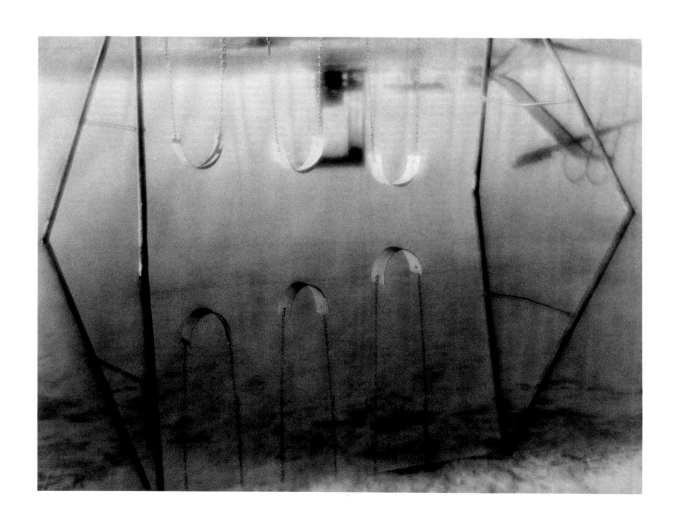

Harry Bowers

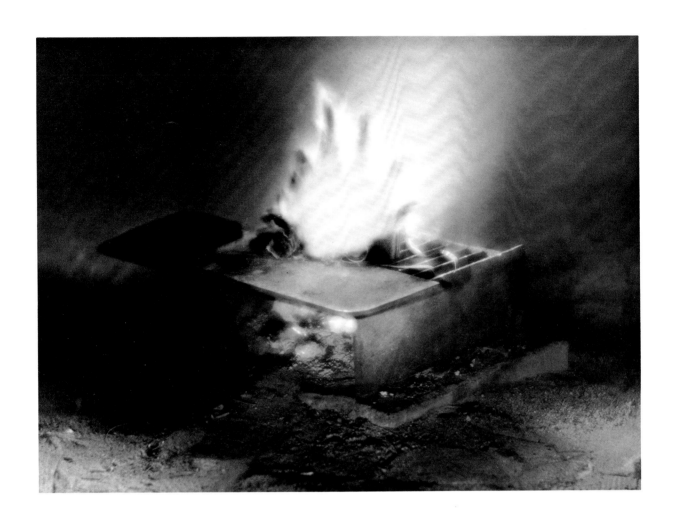

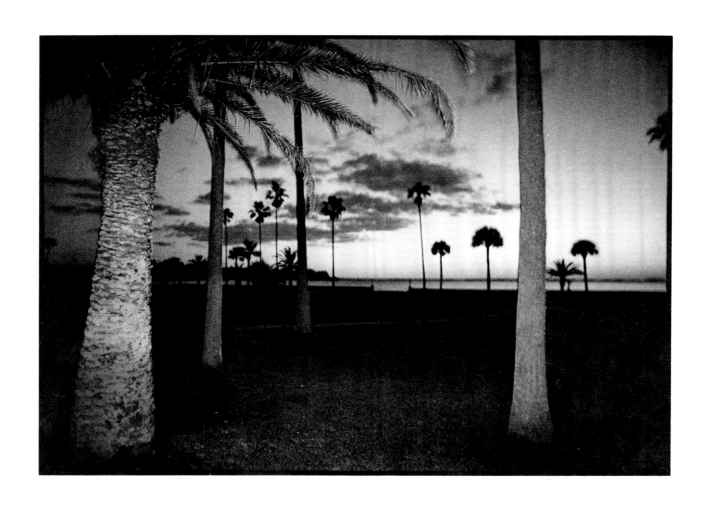

Richard Margolis

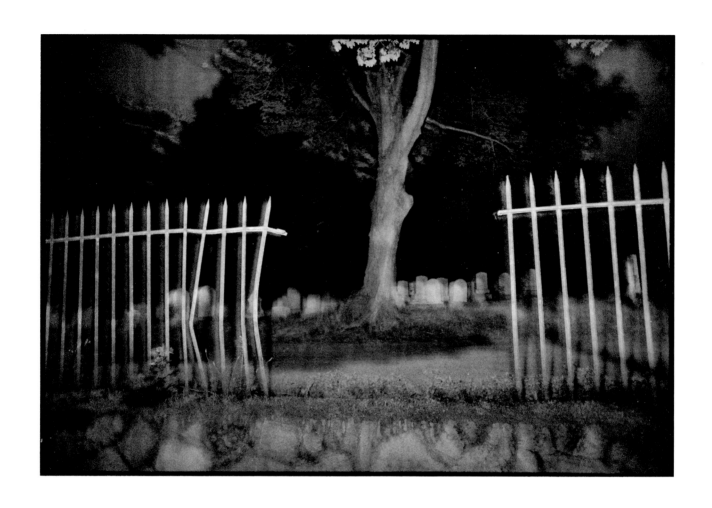

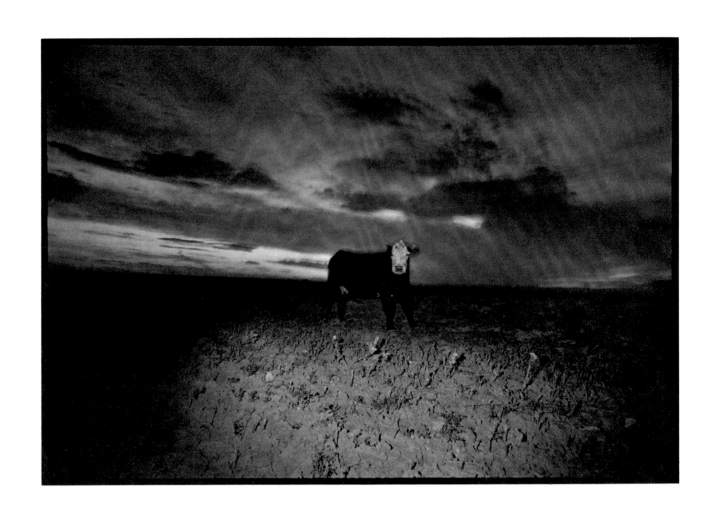

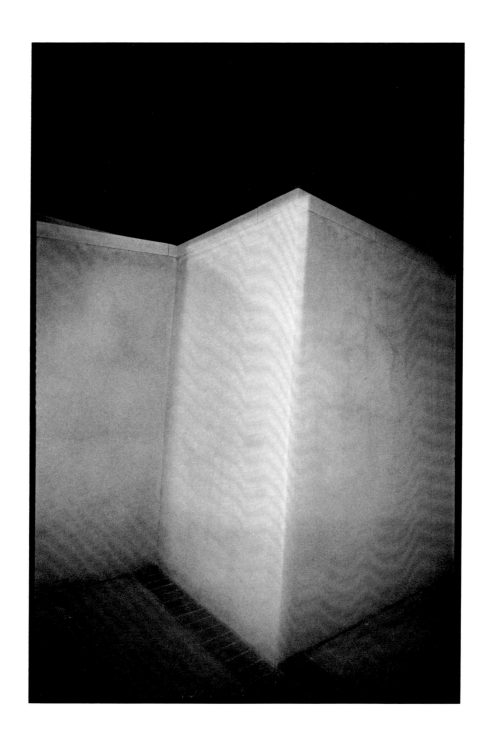

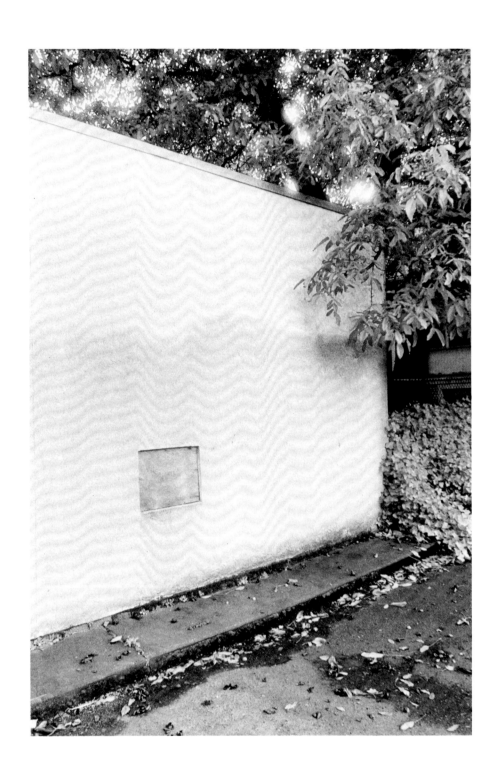

Craig Hickman

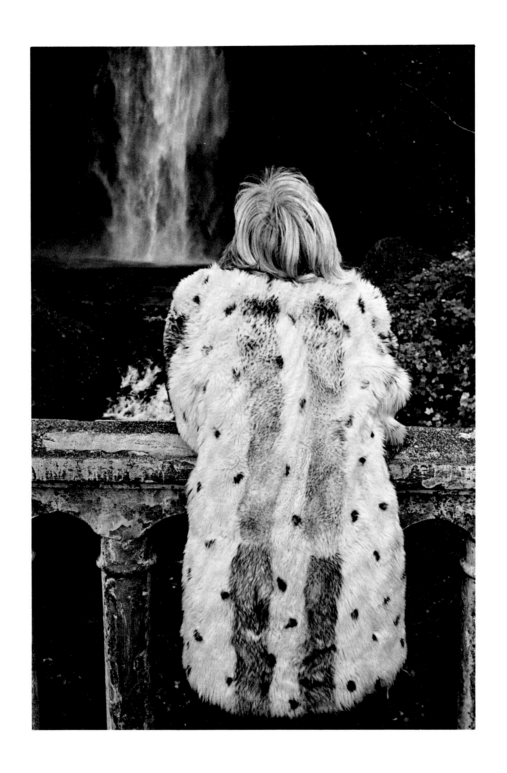

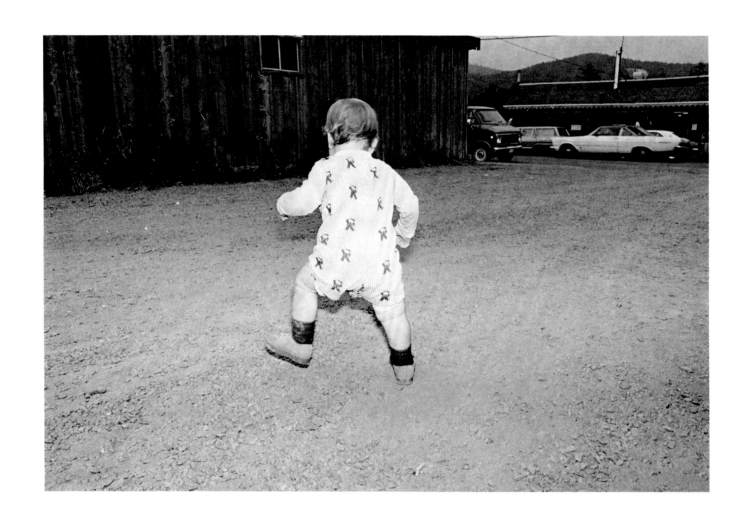

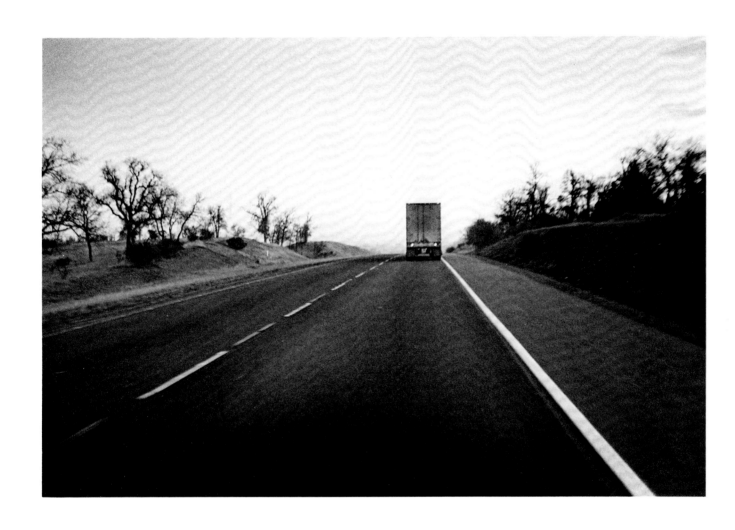

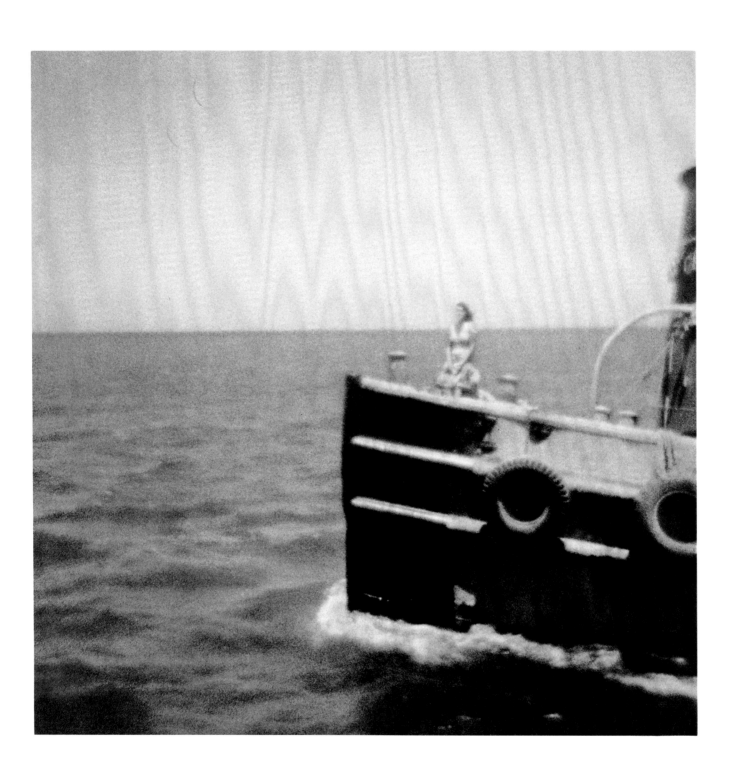

Steve Collins

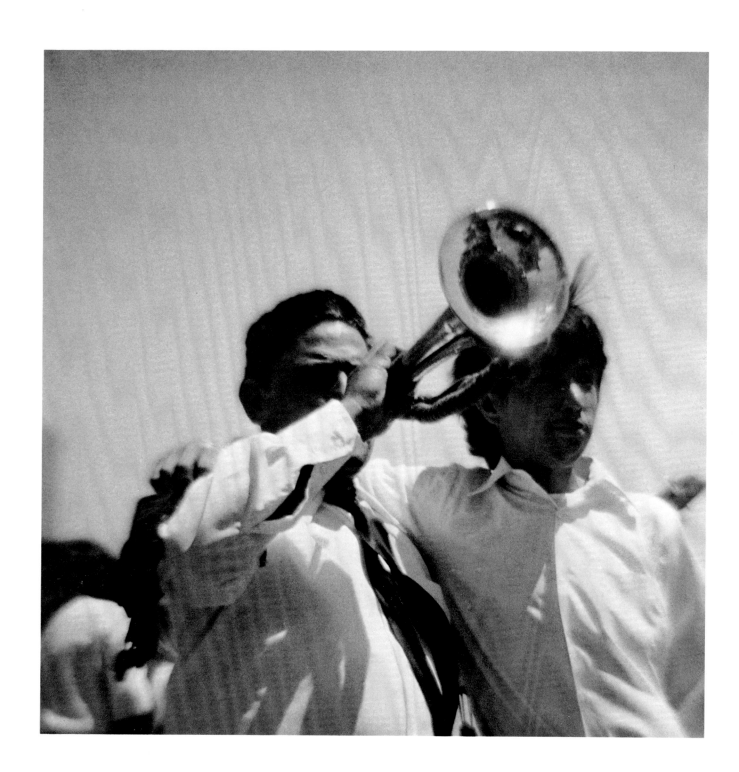

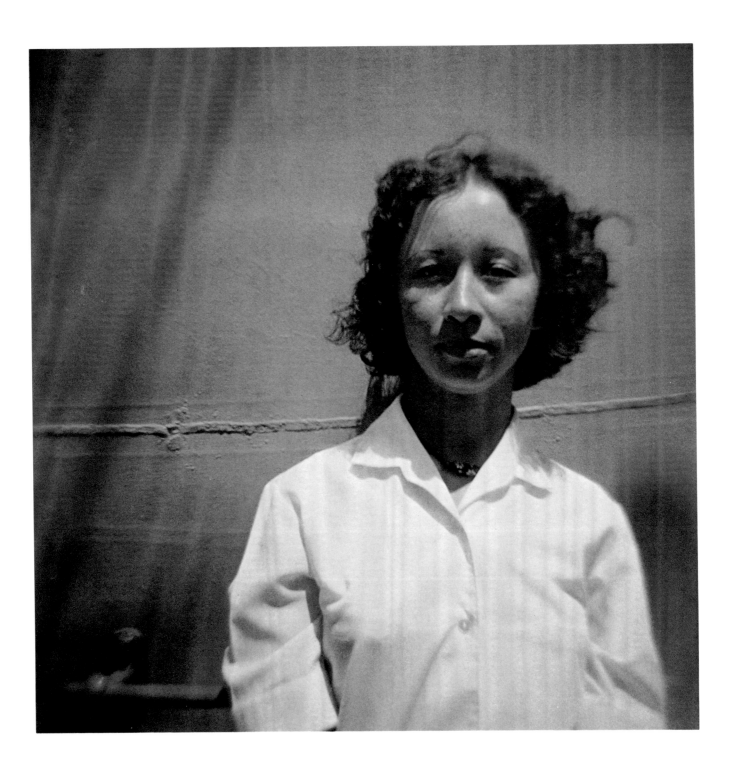

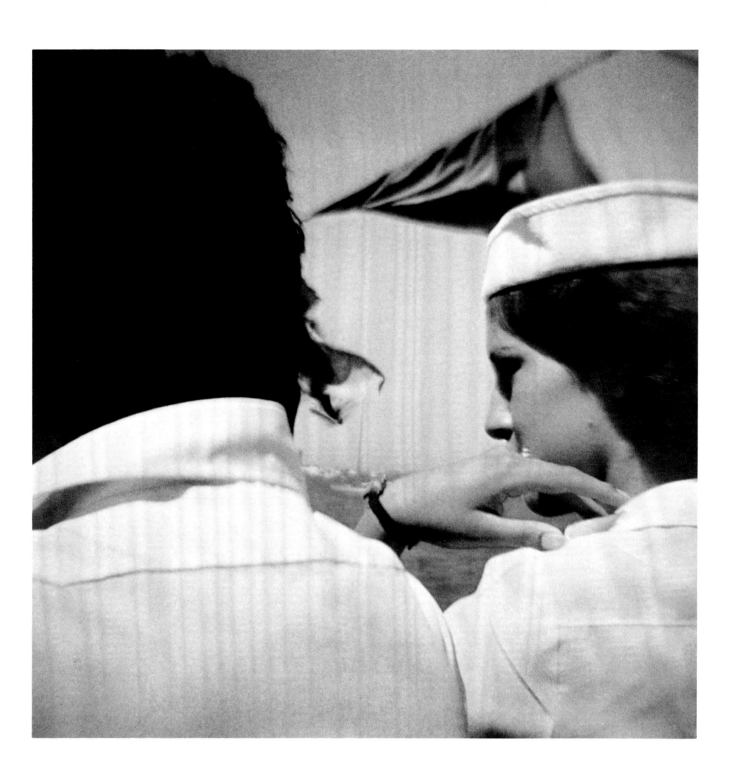

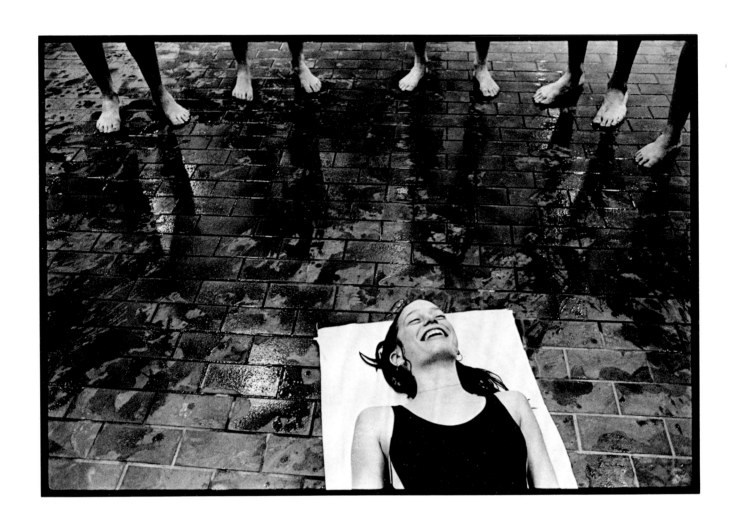

Stewart Tilger

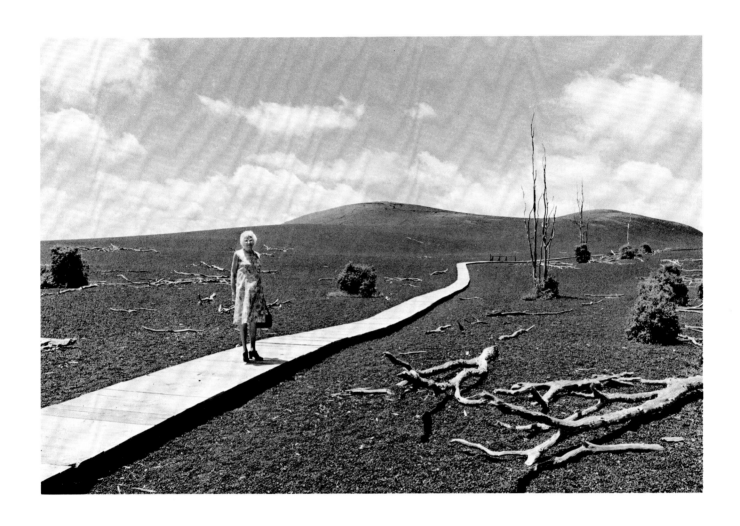

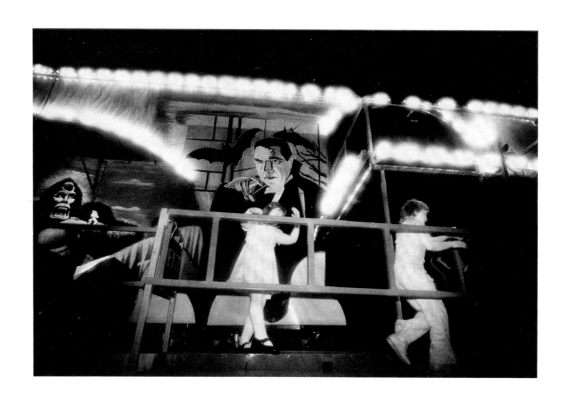

Ford Gilbreath

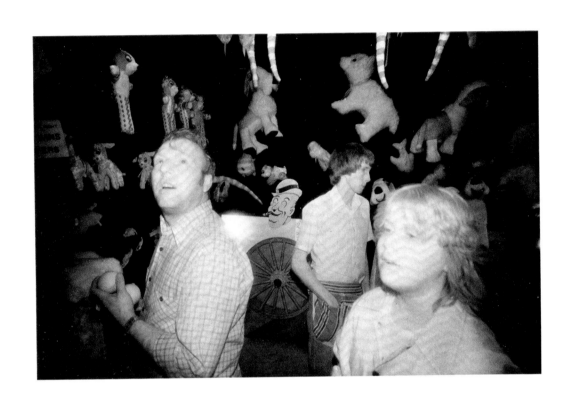

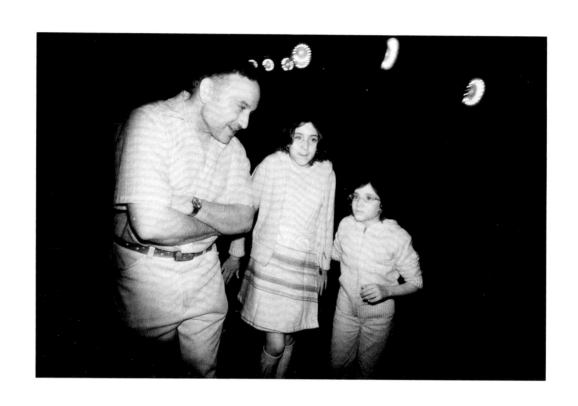

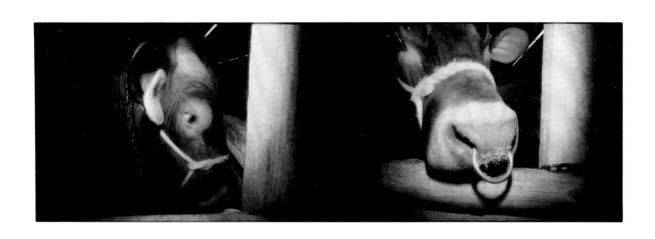

Photographers who appear
in this book